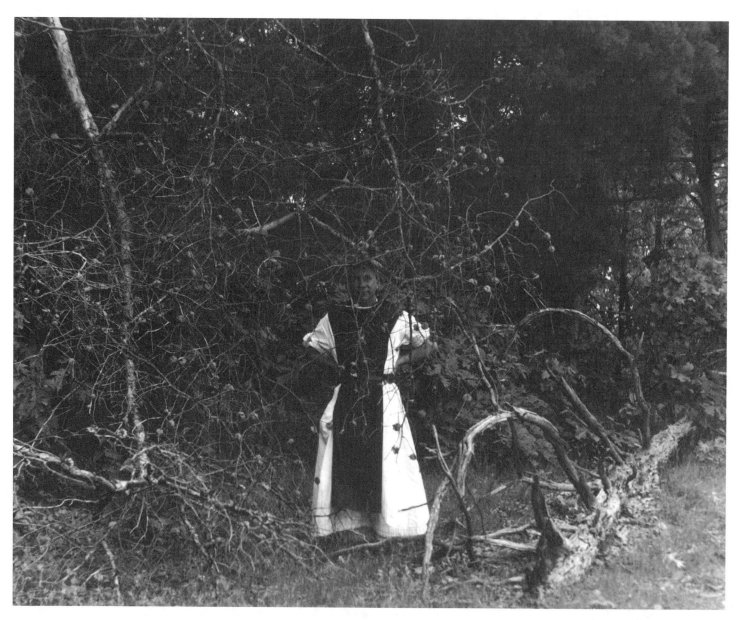

plate 1

MEATYARD / MERTON
MERTON / MEATYARD

Photographing Thomas Merton

PHOTOGRAPHS *by* RALPH EUGENE MEATYARD

CALLIGRAPHIES *by* THOMAS MERTON

WITH INTRODUCTIONS *by* STEPHEN REILY & ROGER LIPSEY

ZEN CAMERA *by* CHRISTOPHER MEATYARD

EXHIBITED AT PUBLIC, THE LOUISVILLE VISUAL ART ASSOCIATION GALLERY,
AT WHISKEY ROW LOFTS, LOUISVILLE, KY
MAY 13 - 22, 2013

THE INSTITUTE FOR CONTEMPLATIVE PRACTICE
SPONSORED BY THE CENTER FOR INTERFAITH RELATIONS
PUBLISHED BY FONS VITAE

THIS PUBLICATION HAS BEEN MADE POSSIBLE BY
2013 FESTIVAL OF FAITHS SACRED SILENCE: PATHWAY TO COMPASSION

LAYOUT AND BOOK DESIGN BY ANNIE LANGAN
PHOTOGRAPHS SELECTED BY JOHN NATION
FOREWORD AND SELECTED EXCERPTS BY STEPHEN REILY

FIRST PUBLISHED IN 2013 BY FONS VITAE
WWW.FONSVITAE.COM

ISBN: 978-1887752-50-3

PRINTED IN CANADA

For the family of Ralph Eugene Meatyard

Jonathan Williams, Guy Davenport and Gene Meatyard were here yesterday ... The one who made the greatest impression on me was Gene Meatyard, the photographer – does marvelous arresting visionary things, most haunting and suggestive, mythical, photography I ever saw. I felt that here was someone really going somewhere.

JUNE 18, 1967

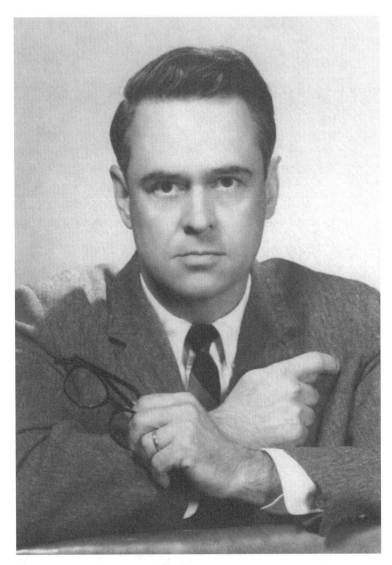

Portrait of Ralph Eugene Meatyard, 1967

Would you be willing to try something in an experimental vein? If not just say so and it will be perfectly all right with me and I will understand. What I propose is to see how closely I, or any artists can connect with the utterances of another. If you were to send me words, prose or poetry and number of words doesn't matter and I don't necessarily understand the personal or private meaning of them – then try to make a photograph or pigraphs of them? We might also if that works try my abstracted photo first and then your words.

AUGUST 12, 1967 MEATYARD TO MERTON

I like very much your suggestion of trying something experimental; poems and pictures. Let's think about that.

AUGUST 15, 1967 MERTON TO MEATYARD

Lens Grinders

In the history of art photography, there are very few examples of someone photographing the same person over and over, across time and many sittings.

Yet in the history of photography between people, between family and friends, perhaps nothing is more common; for many of us, such images are so woven into our lives that they have become inseparable from our idea of intimacy, and from memory itself.

For that reason this series of photographs, by a 20th Century master, of a 20th Century seeker, are especially remarkable, because they combine the formalism and relevance of great art with the intimacy, the playfulness, the casual snapshotty sense of lost time, that arises between dear friends.

Meatyard

Ralph Eugene Meatyard was born in Illinois but spent his adult life in Lexington, Kentucky, where he worked as an optician and raised three children with his wife, Madelyn. He took a course in photography in the early 1950s and soon afterwards began devoting his weekends to taking pictures and his winter nights to developing and printing his growing body of work.

As his artistry grew he befriended the leaders of central Kentucky's mid-century renaissance, including Guy Davenport, Wendell Berry, and Jonathan Williams, each of whom also spread the word about his remarkable talents for both photography and friendship.

By the 1960s Meatyard's work was shown regularly in group exhibits from Arizona to Florida, and in 1970 a traveling solo exhibit of his work gave the world a complete view of this unusual and influential artist.

Meatyard's work is famously difficult to describe because it took so many forms. He is probably best known for somewhat gothic, elegiac photos he took of his children in and around dilapidated houses and farm buildings near Lexington. He classified his own work in several distinct categories with names like No-Focus, Zen Twigs, Romances, Motion-Sound, and Light on Water. Different as this work could be, at least one theme connected it all.

Because he worked full-time and was busy raising his own family in Lexington, Meatyard rarely traveled, and almost never traveled outside Kentucky. But his work does not suffer, it is in fact heightened in its importance, as a result. A constant theme across all of Meatyard's categories is the idea that you can find something interesting no matter where you look. You don't need to travel to make world-class photographs, or to live a remarkable life.

Meatyard offers countless ways to see the world, not by traveling, but by focusing on the world at hand in a manner that is quiet, meditative and constant. He almost sounds like a monk.

Meatyard and Merton

Mutual friends first brought Gene Meatyard to meet Tom Merton in early 1967. Merton was almost 10 years older; he had lived at the Cistercian Abbey of Gethsemani since 1941 and full-time in his hermitage on the grounds there since 1965. Among his many hobbies was photography.

Meatyard and Merton began a friendship that lasted until Merton's death almost two years later, a friendship that was expressed through intense conversation, through correspondence (there are 16 surviving letters between them), and through portrait photography.

Meatyard took 116 photos of Merton, and the 29 prints featured in this exhibit are selected from a portfolio that includes nearly all of

the photographs that Meatyard chose to print. They have also been presented in a book, *Father Louie: Photographs of Thomas Merton by Ralph Eugene Meatyard* (1991), which tells this story in more detail. They were printed by Chris Meatyard, the artist's son.

The first series came from the lunch at Gethsemani when the two met, a four-hour winter conversation over Trappist cheese and bread with bourbon from one of the distilleries nearby. Over the next year-and-a-half Meatyard would photograph Merton in many poses: goofing around with the writer Guy Davenport, acting mythological in the fields of Gethsemani with Jonathan Williams' Appalachian thyrsus (an ancient symbol of fertility and hedonism); drinking beer at a picnic with friends from Louisville; in serious fireside conversation with the poets Wendell Berry and Denise Levertov.

Merton himself wears several costumes: the blue jeans and t-shirt of a mid-60s intellectual; the sturdy dark clothes of a tobacco farmer on Sunday; and the full-out habit of a Cistercian monk. Meatyard milks that habit for all its potential, and through different poses makes Merton the monk look variously like a mannequin, a ghost, a laborer, and a saint. Whether from Meatyard's perspective or our own, Merton in regular clothes always seems present, like part of the crowd, while Merton in his habit usually seems other-worldly, like a creature who has landed in the Kentucky landscape for purposes of art.

With our own God-like knowledge of the past we cannot look at these photographs without seeing something else: the countdown from January 1967 to Merton's final departure from Kentucky in September 1968, and his death in Bangkok three months later.

Maybe as a result, there is both simplicity and infectious joy in the final series, taken only days before his departure, that includes Merton playing the bongo drums, and Merton holding his own Rolleiflex camera to his face. As the Meatyards drove away from his hermitage that day Merton had asked for one more lesson in its use. Meatyard then turned his own camera on Merton and *his* camera in what became a reflective self-portrait between two photographers.

What else was going on during the period of these photographs? In Merton's own life it was a time of upheaval and uncertainty, of almost adolescent turmoil – as reflected in the journal entries that serve as captions to these photographs. When Merton met Meatyard he had just ended – at the demand of his abbot – a six-month affair with a nurse from Louisville. His interest in Eastern religion was intensifying. He was restless and social, but also hungry for the real solitude that he could not give himself in Kentucky. During May 1968 he visited Alaska, Northern California, and New Mexico for retreats, and wondered often if any of these would be a better home for him than Gethsemani. He was, more than ever, bursting the seams that define a monastic life.

Turmoil defined the outer world, too. In these 21 months Bobby Kennedy and Martin Luther King, Jr. were assassinated; the U.S. saw anti-war protests and race riots; and Southeast Asia (where Merton was headed) was in the news every day. Sometimes these worlds met. Just before he met Meatyard the monk had sneaked Joan Baez into his hermitage. This "indescribably sweet" symbol of the new protest culture sang for him, and danced in his fields.

Can we see any of this directly in Meatyard's photographs? No, but: we do see a monk who is not distilled by his years of contemplation but multiplied, protean in costume, guise and affect.

Merton's Calligraphies

Photography was not the only art form that Merton took up in the last 10 years of his life. He also returned to drawing. What he created, inspired by artists like Paul Klee and Zen writers like D. T. Suzuki, were

hand-inked prints that were sometimes representational, but later almost entirely abstract: what Merton called his "calligraphies."

Calligraphies gave Merton several kinds of freedom, including freedom from representational art that might have attracted attention from his superiors. But it also allowed him a kind of freedom from himself, the kind of freedom he found in prayer and in the study of Asian religions that led to his final trip.

Making calligraphies allowed Merton to access a space of "no-mind" that corresponds to Meatyard's own photographs. While some of Merton's friends criticized his calligraphies (which he exhibited during this period at Spalding College in Louisville), it should be no surprise that Gene Meatyard was a fan.

Meatyard held an exhibit of Merton's calligraphies at his Lexington workplace, an exhibit intended to provide Merton with spending money for his trip to Asia. Meatyard himself purchased the eight calligraphies in this exhibit, and they remain in the collection of Gene Meatyard's family today.

Merton's Asian trip left many legacies. It brought him together with the Dalai Lama, who visits Louisville now almost 45 years after their meetings in Dharamsala. It spawned endless speculation about Merton's religious growth: would he have turned more seriously to Buddhism? It also left his growing relationship with the Meatyards – including the series of portraits shown here – frozen in time.

Meatyard and Merton

Barely two years after Merton's death Meatyard was diagnosed with cancer. He continued to make eyeglasses and take pictures until his own death, at age 46, in 1972.

Meatyard wrote about Merton after the monk's death, but what he felt about their connection seems captured most purely in these photographs, in the letters between himself and Merton (some of which are quoted in captions here), and in the way he lived his final years.

Wendell Berry, who knew both Merton and Meatyard, wrote this about that period: "After he became ill with cancer, Gene continued to come with his family to visit us on Sundays. He continued to come after he was unable to swallow food; he would sit in the living room while the rest of us ate dinner in the kitchen. And he never conceded by so much as a look that these circumstances were the least bit out of the ordinary. Though he was dying, what he was doing was living."

In this exhibit we see not just portraits of a famous man, and not just portraits of a friendship, but portraits of vision itself, of observation as a kind of love.

At work every day, Meatyard gave people better vision through eyeglasses; in his own vision he saw multiples. He saw multiples in Merton.

In Merton's work, we find a kind of clarity that can focus our own post-modern lives. Yet for Merton, nothing that focused him could contain him. He saw himself in multiples, and let Gene Meatyard see it, too. They saw it in each other. •

plates

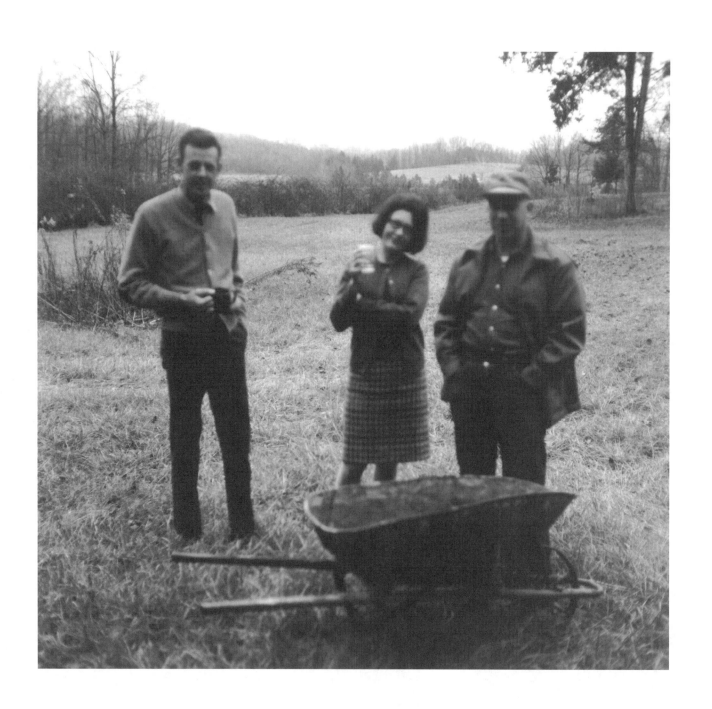

Monasticism. I see more and more the danger of identifying the monastic vocation and spirit with a particular kind of monastic consciousness – a particular tradition, however "authentic."... Maybe monasticism needs to be stated all over again in a new way. I have no way of knowing how to tackle this idea. It is just beginning to dawn on me.

FEBRUARY 6, 1967

plate 2 WENDELL BERRY, DENISE LEVERTOV AND THOMAS MERTON

It is the twenty-fifth anniversary of my taking the novice habit ... I find that I certainly do not believe in the monastic life as I did when I entered here when I was more sure I knew what it was. Yet I am much more convinced I am doing more or less what I ought to do, though I don't know why and cannot fully justify it.

<div align="right">

FEBRUARY 22, 1967

</div>

<div align="right">

plate 3

</div>

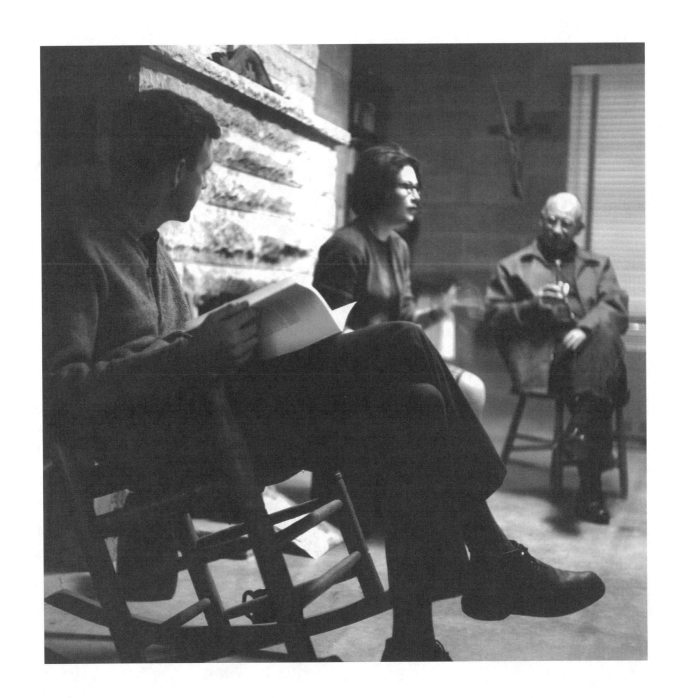

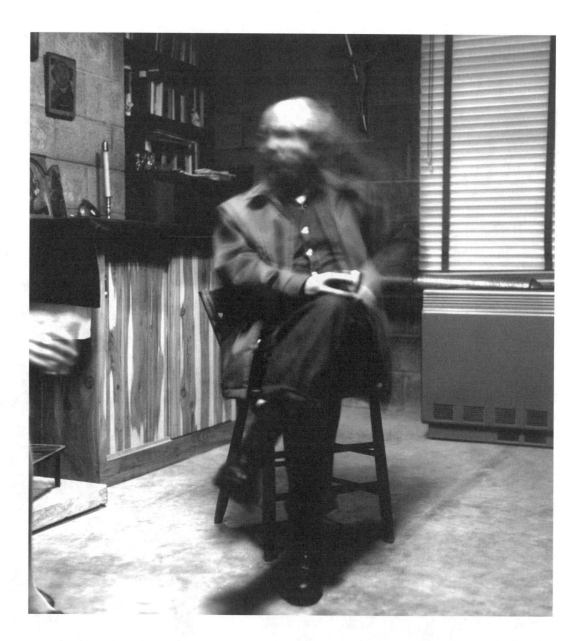

plate 4

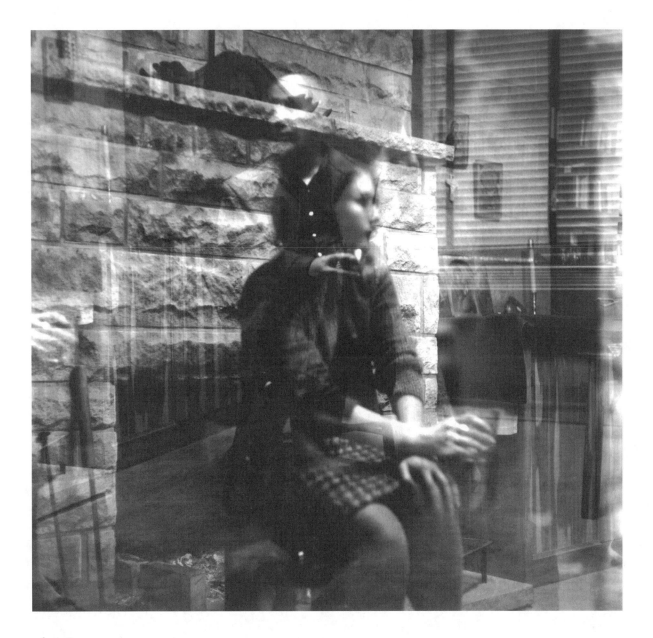

plate 5

I know that our love affair is really all over and there is no point trying to keeping it alive. Certainly I miss her, but one has to face facts. I am humbled and confused by my weakness, my vulnerability, my passion. After all these years, so little sense and so little discipline. Yet I know there was good in it somewhere, nevertheless.

MARCH 3, 1967

[Y]esterday was utterly different. Once again the old freedom, the peace of being without care, of not being at odds with the real sense of my own existence and with God's grace to me. Far better and deeper than my consolation of eros.

APRIL 10, 1967

What is "wrong" in my life is not so much a matter of "sin" (though it is sin too), but of unawareness, lostness, slackness, relaxation, dissipation of desire, lack of courage and of decision, so that I let myself be carried along and dictated to by an alien movement ... Only if I go where I must go can I be of any use to "the world." I can serve the world best by keeping my distance and my freedom.

MAY 14, 1967

plate 6

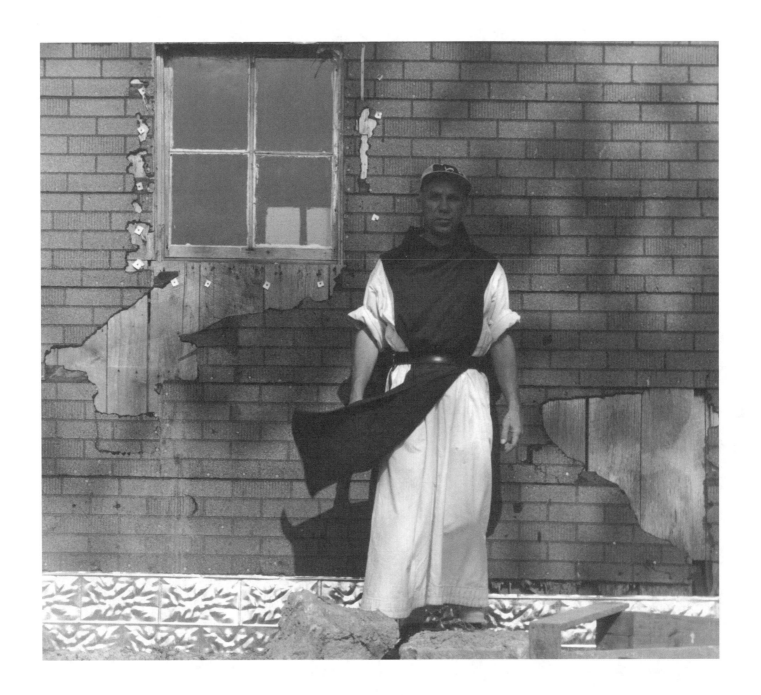

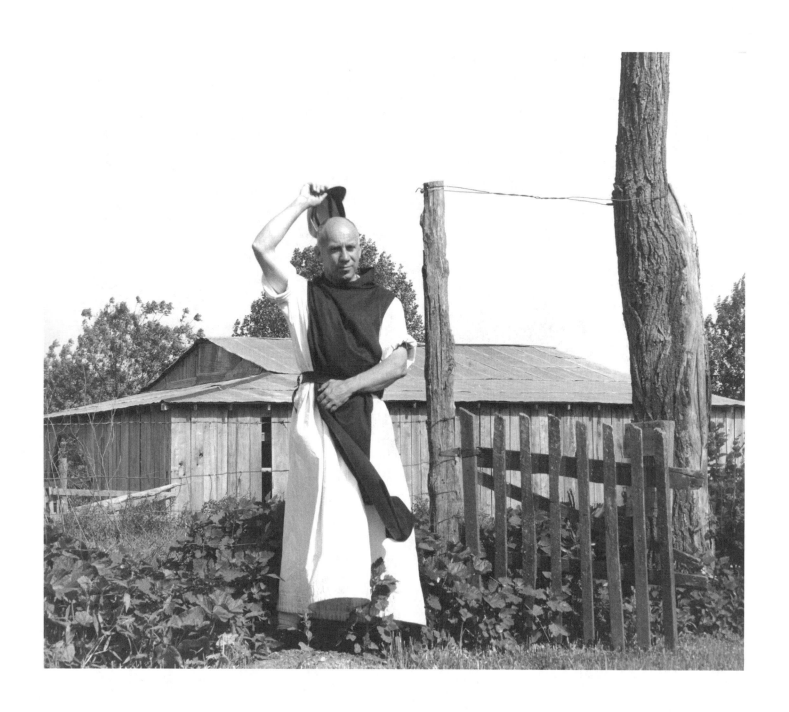

[S]he keeps urging me to leave the monastery so that I can "be myself." There is probably something to that, but is it quite so simple? I doubt that: the whole massive politic of getting out and getting established elsewhere is beyond me now, and there is really nowhere else I want to live but in this hermitage.

<div align="right">JUNE 21, 1967</div>

Guy Davenport and Gene Meatyard (and Maddie) are also good to talk to, and with Gene and his ideas for photographs I always find we are doing something exciting and good.

<div align="right">JULY 27, 1967</div>

Evening. I sit up late again listening to crickets and frogs because I can't go to bed yet. I had to translate in Chapter again tonight – which is not my business at all ... It was childish. I am ashamed of myself. I did the best I could and it was silly. So I pretend I belong here (as if I belonged somewhere). The woods, Okay. But I came back feeling sad. I realize it is this way almost everywhere and with everyone except very few people ... Fortunately I had some bourbon in the hermitage.

<div align="right">AUGUST 2, 1967</div>

plate 7

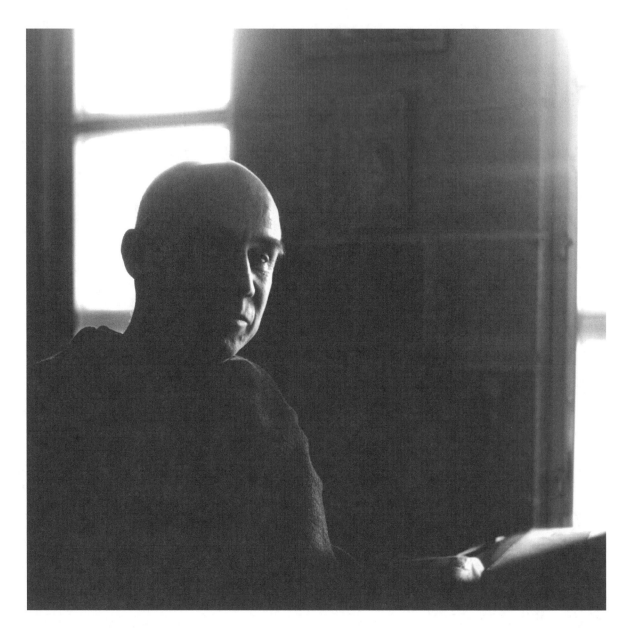

plate 8

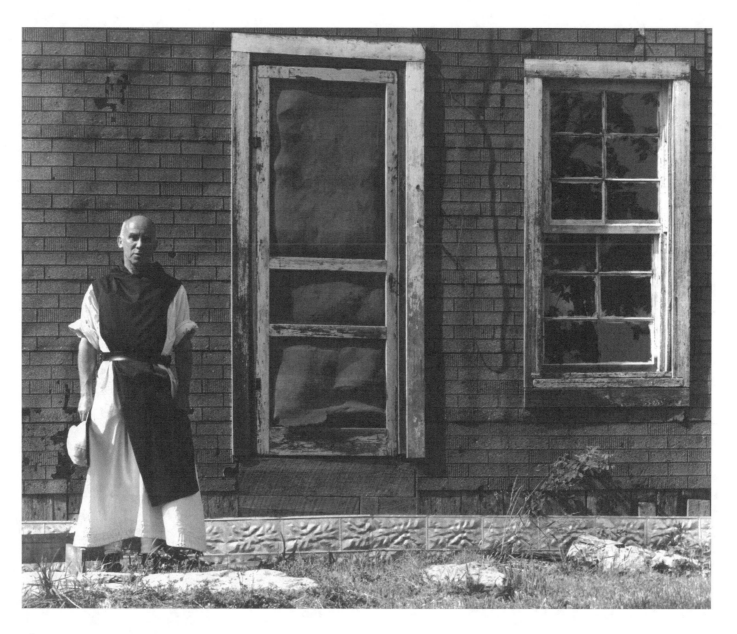

plate 9

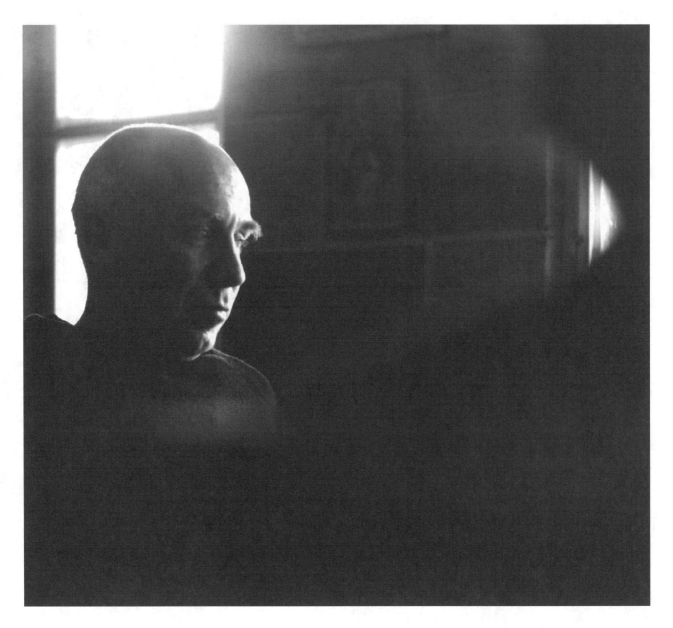

plate 10

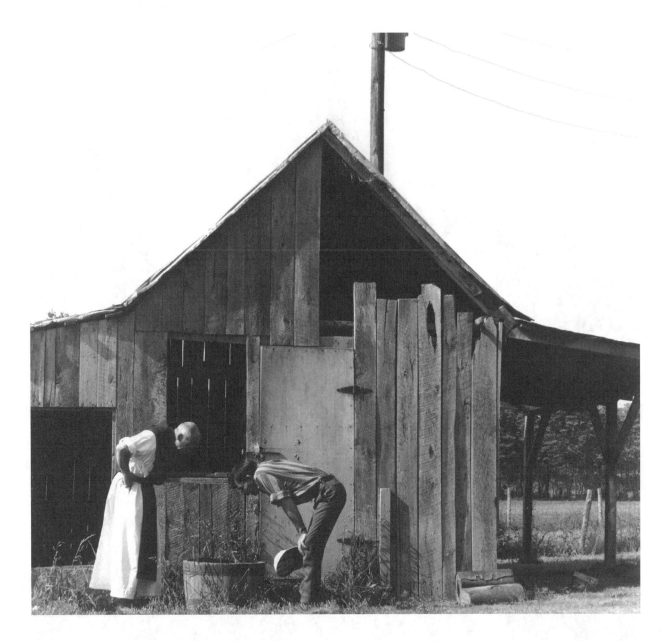

plate 11

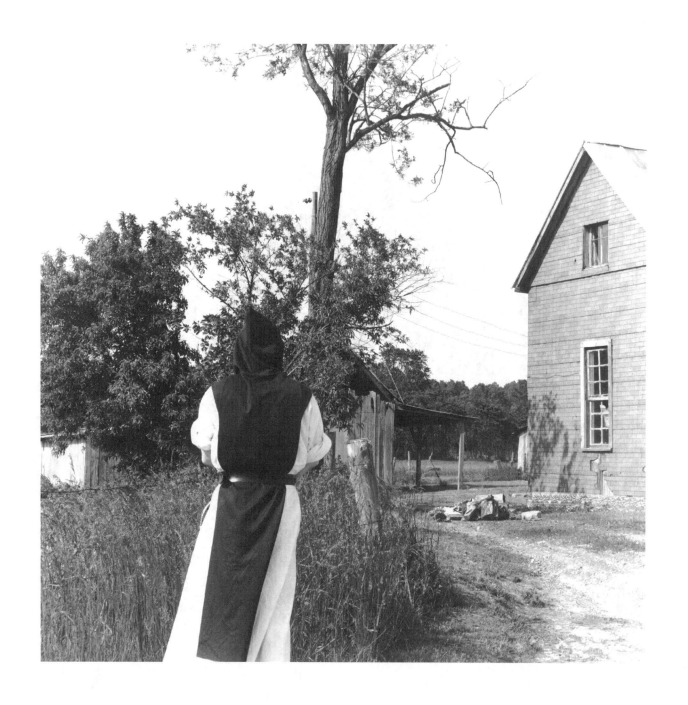

The ambiguities at work here: the pretended "roots" at Gethsemani, where I am alien and where most everyone else is alien too. Yet paradoxically to many people I am completely identified with this strange place I can't firmly believe in ... Yet there is nowhere else I want to go ...

OCTOBER 2, 1967

I myself am open and closed. When I reveal most I hide most. There is still something I have not said: but what it is I don't know, and maybe I have to say it by not saying. Word play won't do it. Writing this is most fun for me now, because in it I have finally got away from self-consciousness and introversion. It may be my final liberation from all diaries. Maybe that is my one remaining task.

OCTOBER 2, 1967

plate 12

Blazing bright days, cool nights, my face still hot from burn as we sat yesterday at the top of the long new farm cornfield – Gene Meatyard, Jonathan Williams, Guy Davenport, Bonnie and I – in noon sun and drank some beer. Hills glimmering with heat and color. Sky deep blue. All distances sharp. White dead corn leaves blowing about in the hot dust of the field, fully ravaged. Gene brought some of his photos – including ones taken around the beatup house down the road in June.

<div style="text-align:right;">

OCTOBER 23, 1967

</div>

Strange feeling! Recapturing the freshness of those days when my whole monastic life was still ahead of me, when all was still open. Now it is all behind me and the years have closed in upon their silly, unsatisfactory history, one by one. But the air is like spring and fresh as ever, and I was amazed at it.

<div style="text-align:right;">

NOVEMBER 25, 1967

</div>

<div style="text-align:right;">

plate 13

</div>

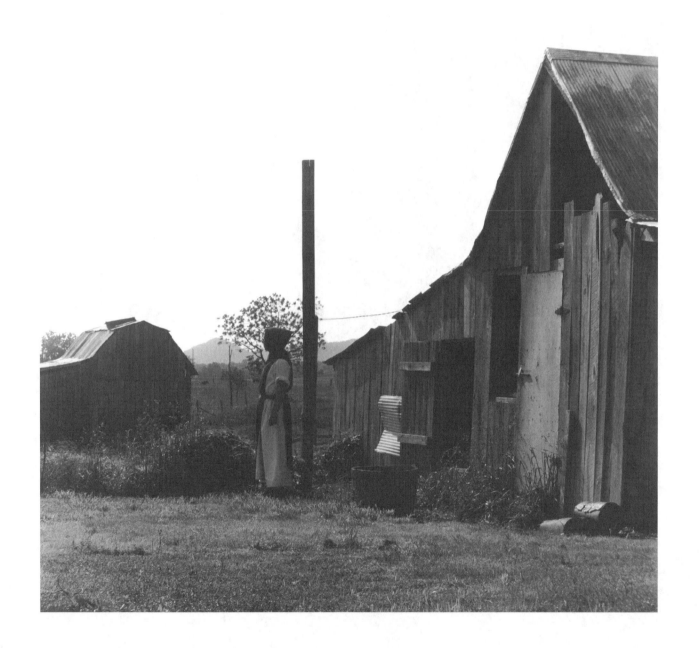

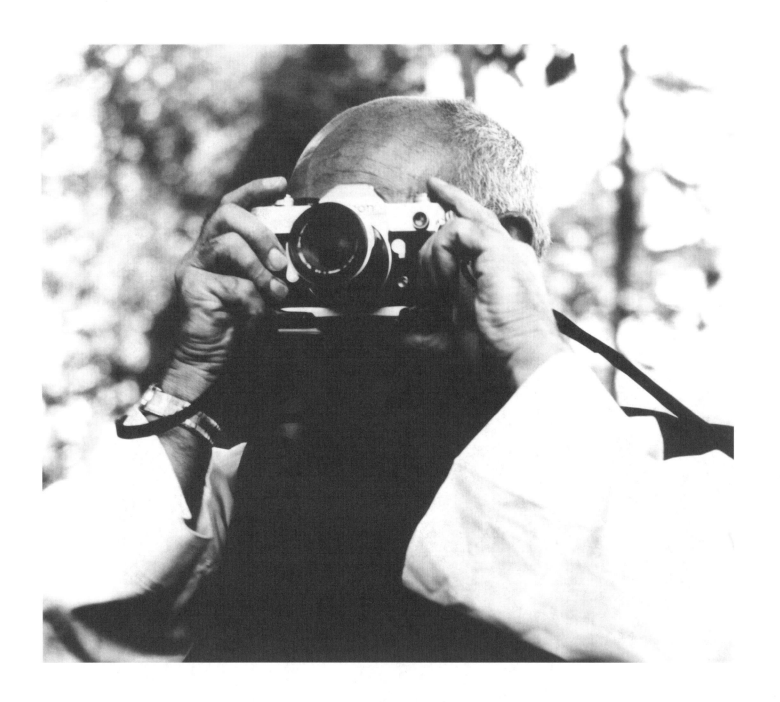

The last four or five days [on retreat at Gethsemani] have been quite fantastic: among the most unusual in my life. I hardly know how to write about them. There should be a whole new key – a kind of joy unusual in this journal – where I am usually diffident and sad. I have to change the superficial ideas and judgments I have made about the contemplative religious life, the contemplative orders. They were silly and arbitrary and without faith.

DECEMBER 7, 1967

Certainly I feel less real, somehow, without our constant communication, our sense of being in communion (so intense last year). The drab, futile silliness of this artificial life with all its tensions and its pretenses, but I know it would be worse somewhere else. Marriage, for me, would be terrible! Anyway, that's all over. In a month I'll be 53, and no one in his right mind would be married for the first time at such an age. Yet this afternoon I wondered if I'd really missed the point of life after all. A dreadful thought.

DECEMBER 23, 1967

plate 14

The murder of Martin Luther King lay on top of the traveling car like an animal, a beast of the apocalypse. It finally confirmed all the apprehensions – the feeling that 1968 is a beast of a year, that things are finally and inexorably spelling themselves out.

<div align="right">

APRIL 6, 1968

</div>

The last three days of Holy Week were beautiful, brilliant days. The finest of all the spring. My redbuds are in bloom and the apple trees are in full bloom down by the monastery beehives. It was wonderful today walking under their great dim clouds full of booming bees.

<div align="right">

APRIL 14, 1968 EASTER SUNDAY

</div>

<div align="right">

plate 15

</div>

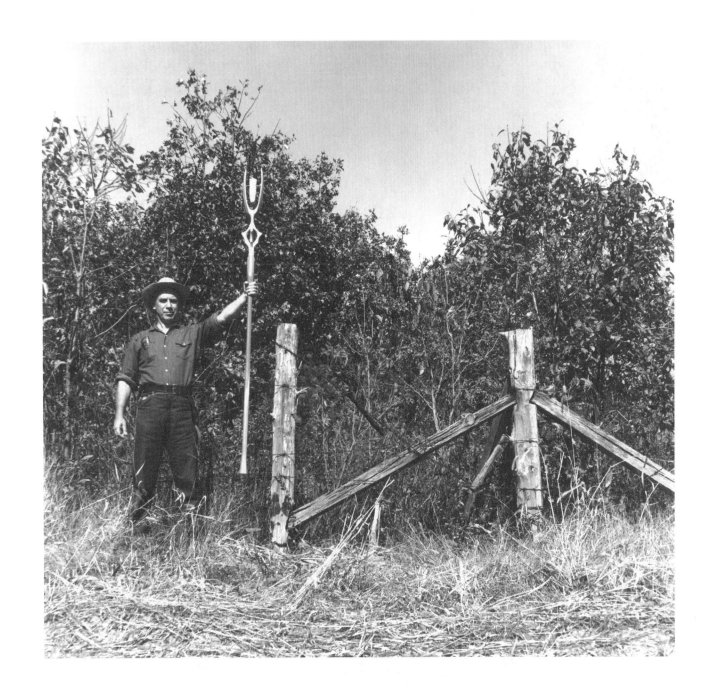

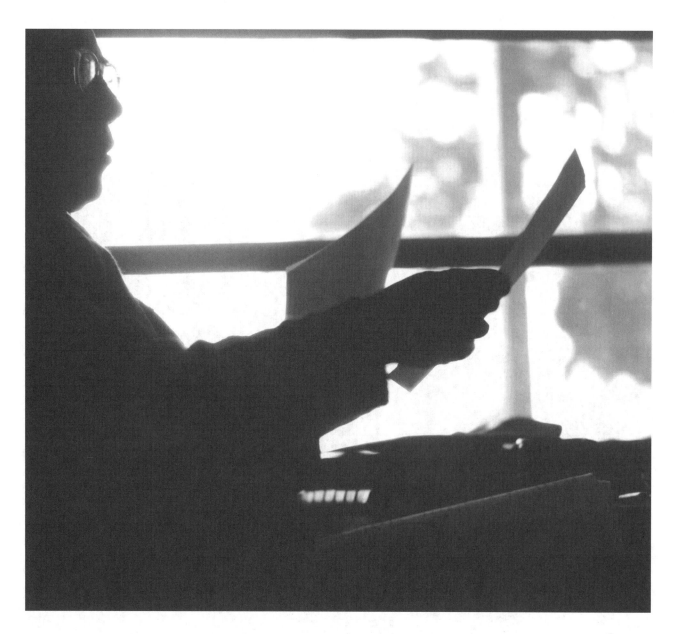

plate 16

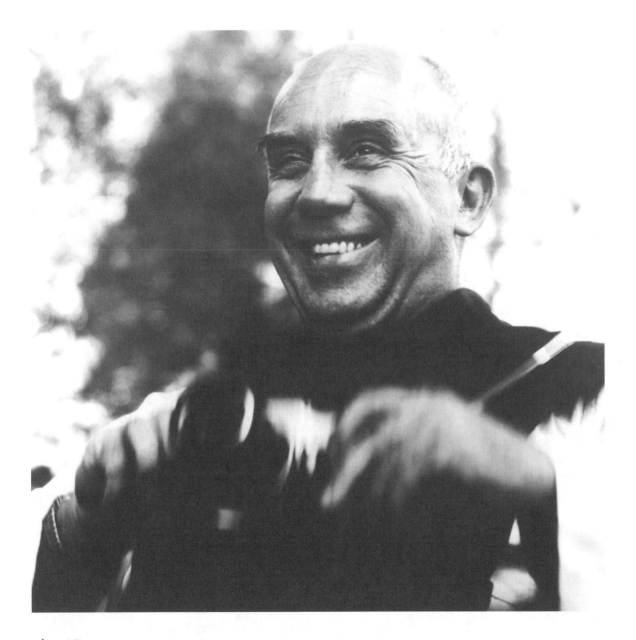

plate 17

The problem of real solitude: I don't have it here. I am not really living as a hermit. I see too many people, have too much active work to do, the place is too noisy, too accessible. People are always coming up here ... Everyone now knows where the hermitage is, and in May I am going to the convent of the Redwoods in California. Once I start traveling around, what hope will there be?

<div align="right">APRIL 16, 1968</div>

In our monasteries we have been content to find our way to a kind of peace, a simple, undisturbed, thoughtful life. This is certainly good, but is it enough? I, for one, realize that now I need more. Not simply to be quiet, somewhat productive, to pray, to read, to cultivate leisure — otium sanctum? There is a need of effort, deepening, change and transformation ... I do have a past to break with, an accumulation of inertia, waste, wrong, foolishness, rot, junk, a great need of clarification of mindfulness, or rather of "no mind" — a return to genuine practice, right effort, need to push on to the great doubt. Need for the Spirit.

<div align="right">MAY 21, 1968</div>

<div align="right">plate 18</div>

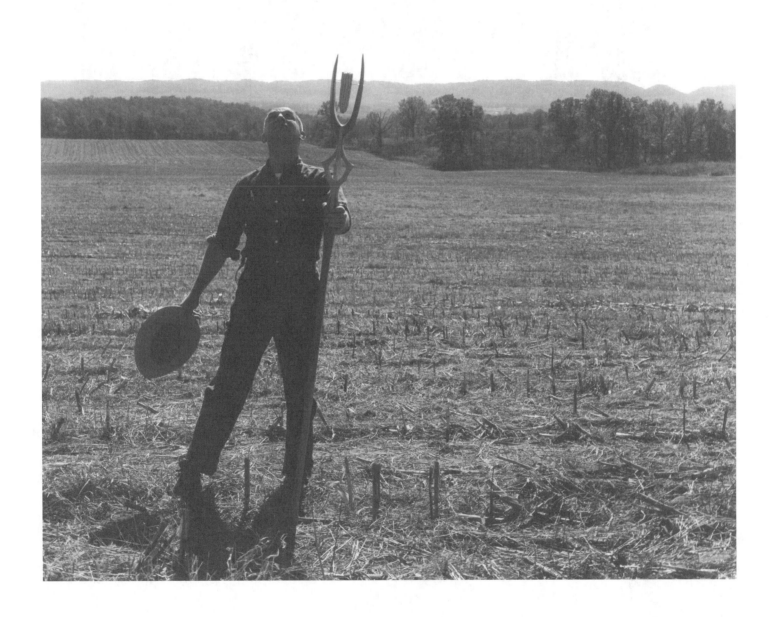

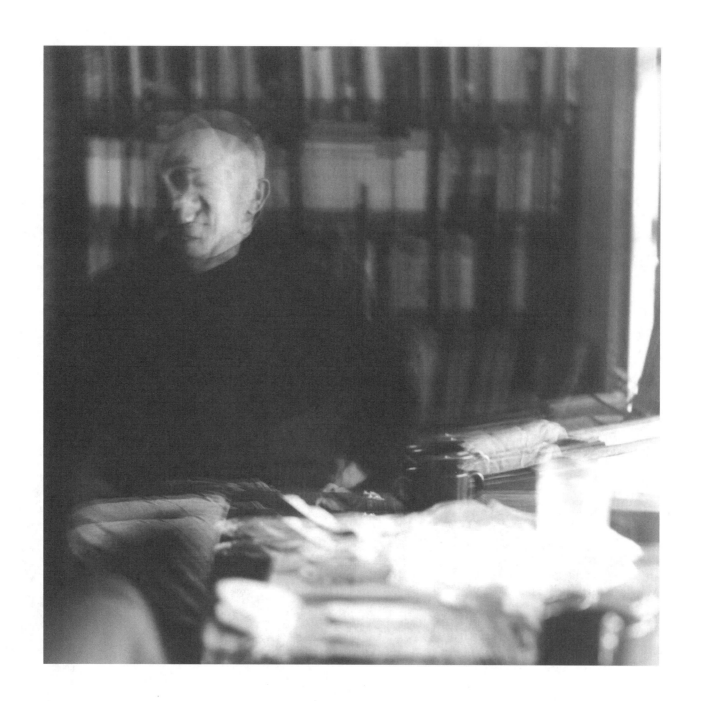

Whether I ever get to Asia or not, I see the importance of real seriousness about meditative discipline and deepening — not just quiet and privacy (which I don't always have anyway). Have really reached the point in my life where one thing only is important: call it "liberation" or whatever you like.

If you can get over one of these weekends, let's get together for a sandwich al fresco. Hoping for some fresco weather and not just the kind of general steam heat we've got now.

JUNE 26, 1968 MERTON TO MEATYARD

plate 19

It would do no good to anyone if I just went around talking – no matter how articulately – in this condition. There is still so much to learn, so much depending to be done, so much to surrender. My real business is something far different from simply giving out words and ideas and "doing things" – even to help others. The best thing I can give to others is to liberate myself from the common delusion and be, for myself and for them, free. Then grace can work in and through me for everyone.

JUNE 29, 1968

plate 20

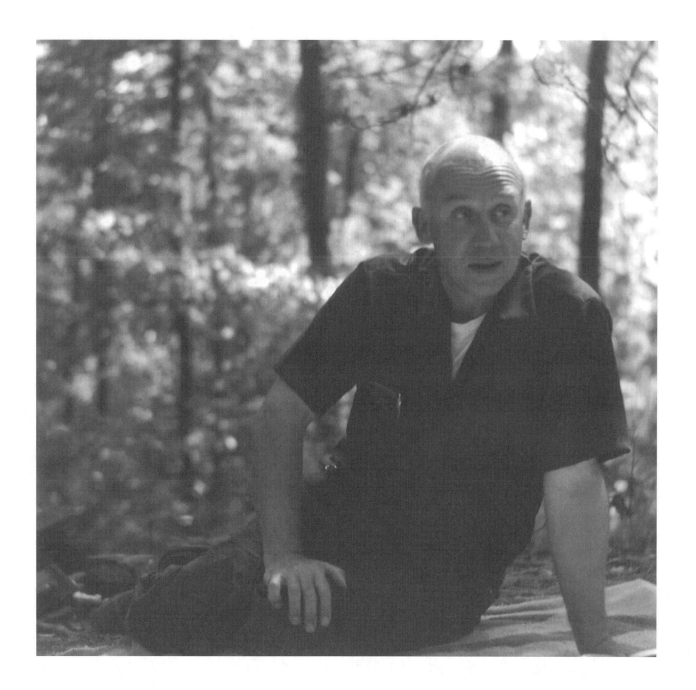

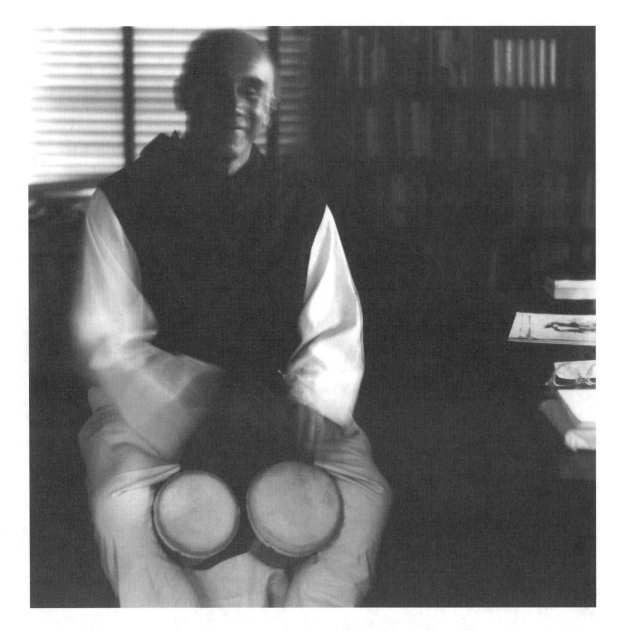

plate 21

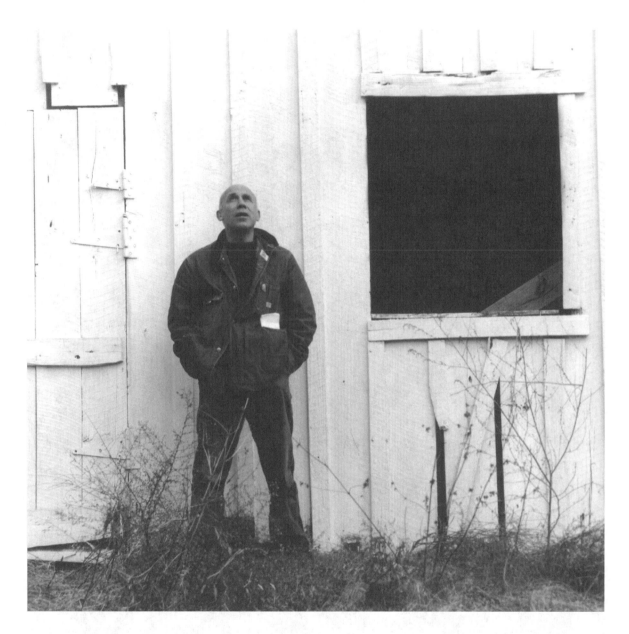

plate 22

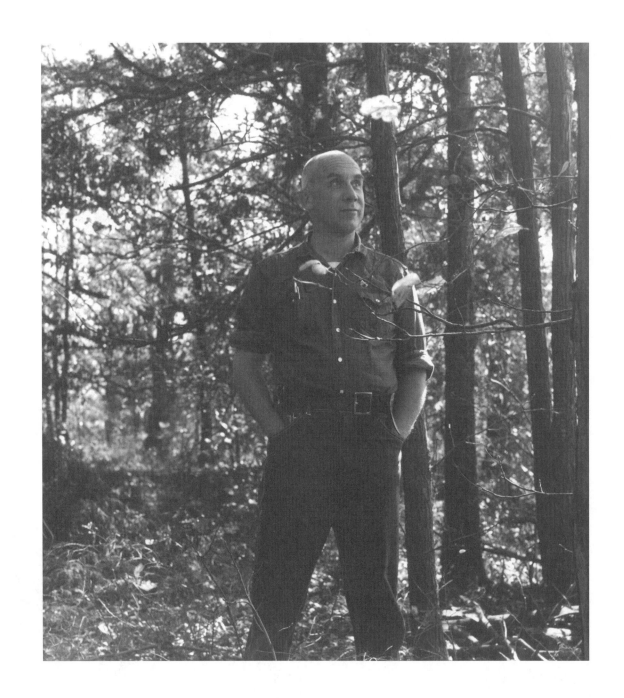

I love the woods, particularly around the hermitage. Know every tree, every animal, every bird. Sense of relatedness to my environment – a luxury I refuse to renounce. Aristocrat, conservative: I don't give a damn.

<div align="right">

MARCH 23, 1967

</div>

In eight weeks I am to leave here. Who knows, I may not come back. Not that I expect anything to go wrong – though it might – but I might conceivably settle in California to start the hermit thing Father Flavian spoke of: it depends … Really I don't care one way or another if I never come back.

<div align="right">

JULY 29, 1968

</div>

I really expect little or nothing from the future. Certainly not great "experiences" or a lot of interesting new things. Maybe, but so what? What really intrigues me is the idea of starting out into something unknown, demanding and expecting nothing very special, hoping only to do what God asks of me, whatever it may be.

<div align="right">

JULY 29, 1968

</div>

plate 23

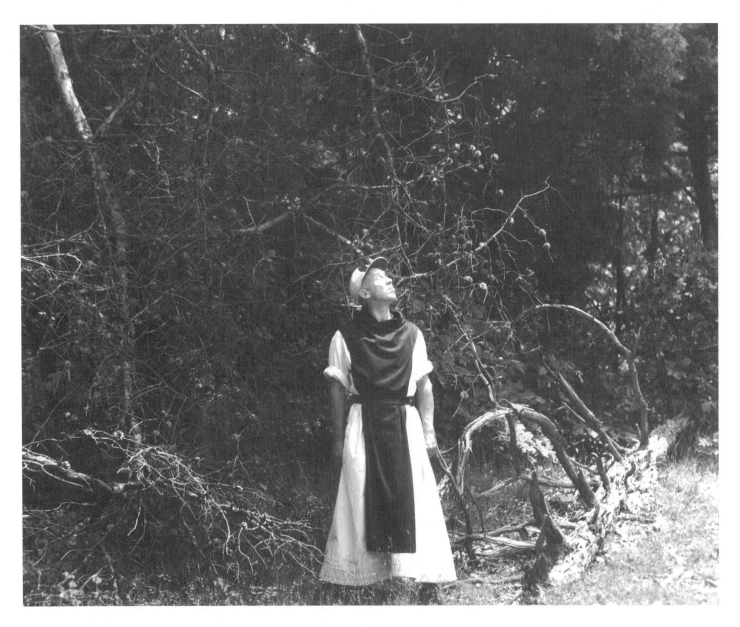

plate 24

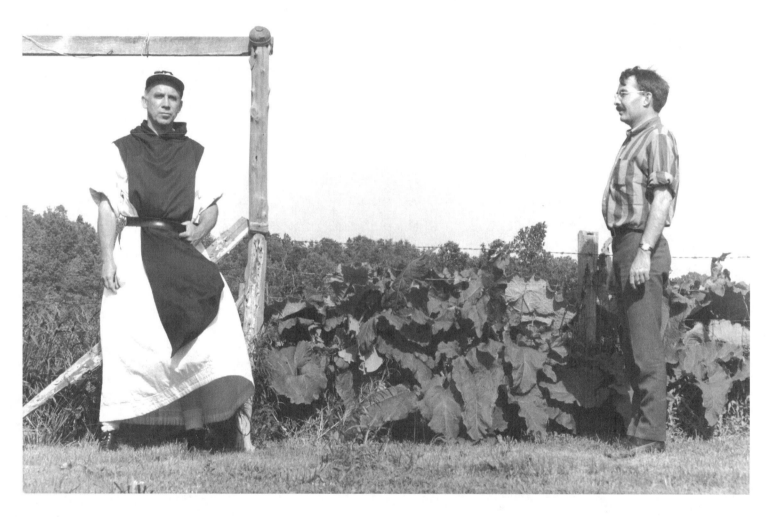

plate 25 THOMAS MERTON AND GUY DAVENPORT

Gene Meatyard with Madeline and Chris and Melissa came over today. We ate curry and drank daiquiris and listened to calypso music. Yesterday Bob and Hannah Shepherd came over. Everyone says: "Be sure to come back," as if I might not."

SEPTEMBER 2, 1968

plate 26

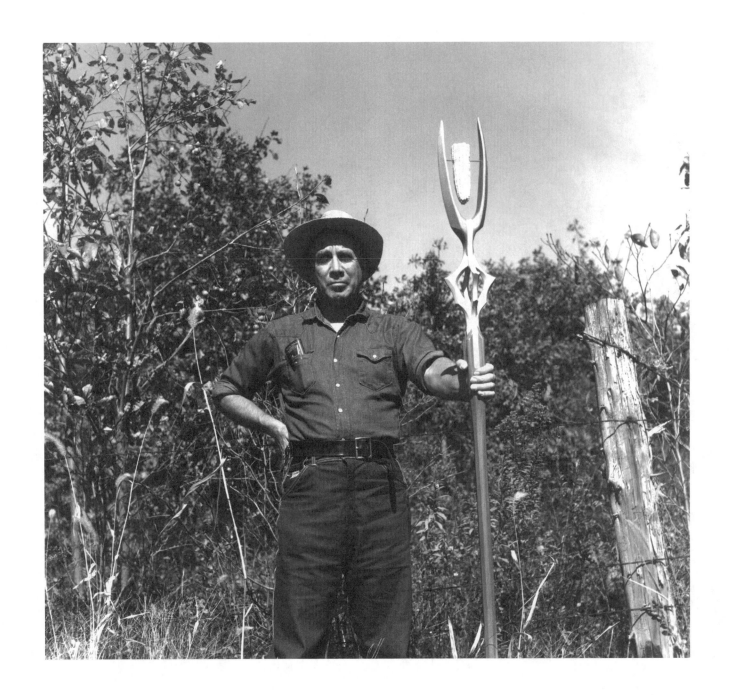

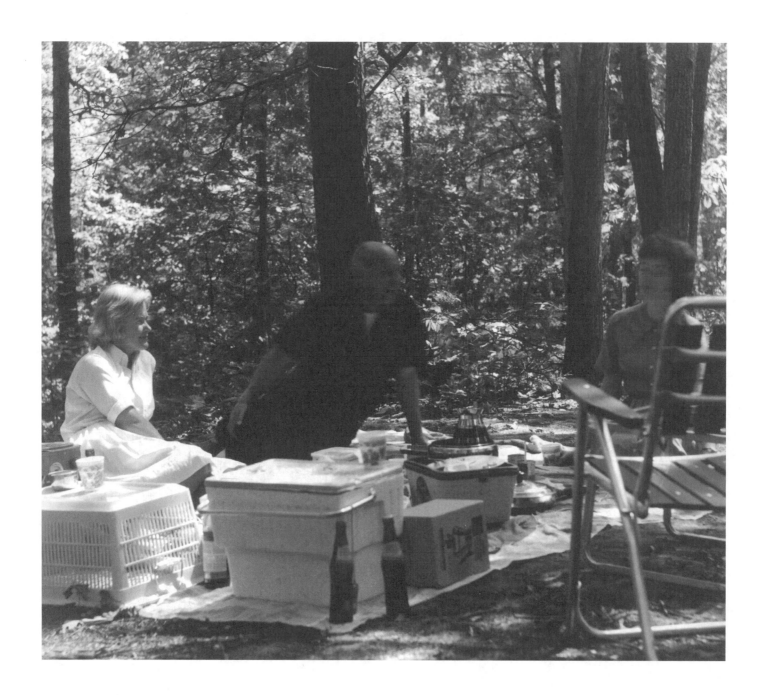

It is hard to believe this is my last night at Gethsemani for some time – at least for several months ... I go with a completely open mind. I hope without special illusions. My hope is simply to enjoy the long journey, profit by it, learn, change, perhaps find something or someone who will help me advance in my own spiritual quest.

SEPTEMBER 9, 1968

plate 27 MADELYN MEATYARD, THOMAS MERTON AND TANYA BERRY

I am not starting out with a firm plan never to return or with an absolute determination to return at all costs. I do feel there is not much for me here at the moment and that I need to be open to lots of new possibilities. I hope I shall be! But I remain a monk of Gethsemani. Whether or not I will end my days here, I don't know. Perhaps it is not so important. The great thing is to respond perfectly to God's Will in this providential opportunity, whatever it may bring.

SEPTEMBER 9, 1968

plate 28 GUY DAVENPORT, THOMAS MERTON AND MADELYN MEATYARD

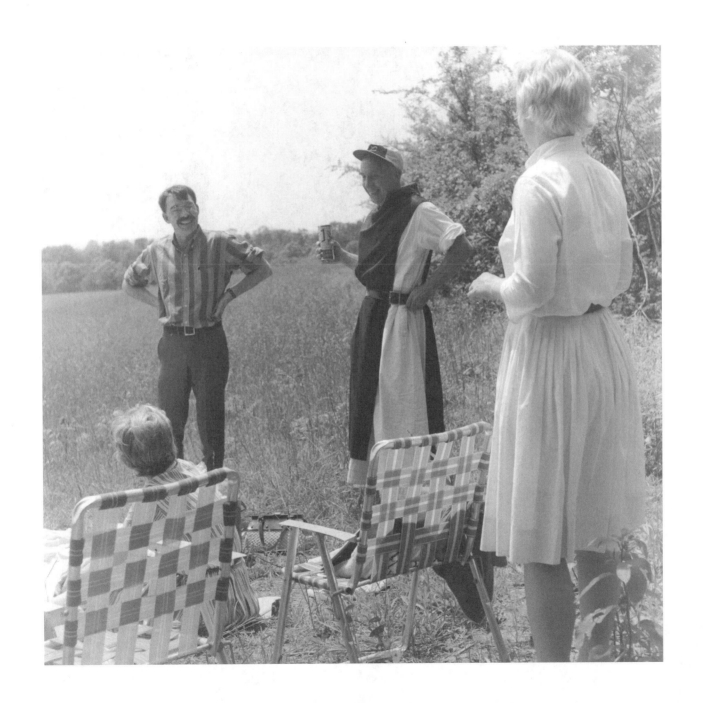

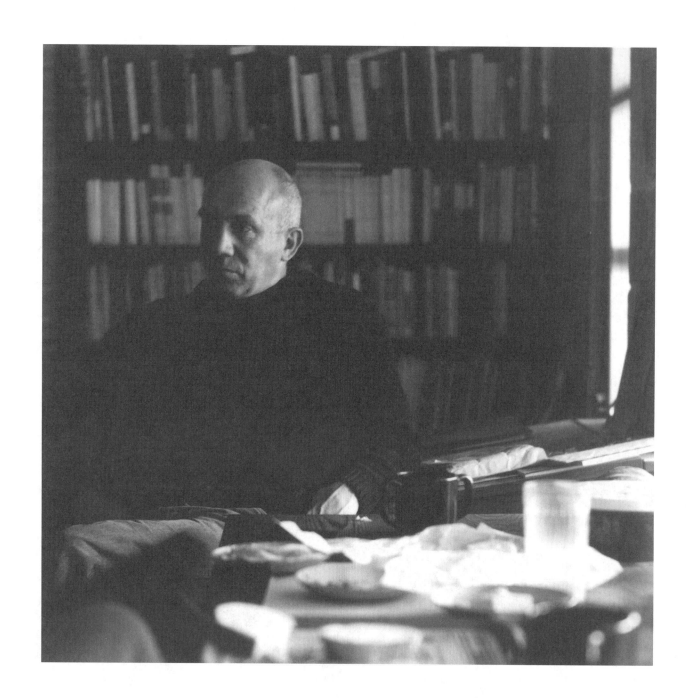

Saw the Dalai and a flock of other Lamas and had some great talks with them. Real disciplined meditation outfits they have! After about a month with Tibetans here and there I've come south – like it a lot, wish I had more time here – off to Ceylon this afternoon, then Bangkok until Dec 15 ... After that I'll be at a monastery in Indonesia until right after Xmas ... After that I don't know for sure. Anything is possible as long as the money doesn't give out ... Love to all, Merry Christmas in case I don't get a chance to write fast again.

<div align="right">

NOVEMBER 28, 1968 MERTON TO MEATYARD

</div>

plate 29

Merton's Calligraphy

Merton's long experiment with abstract calligraphy dates to the hermitage period. Befriending him in 1967, Gene Meatyard came along at a time when Merton already had several years of experience and a considerable stock of drawings. In the famous photograph of Merton playing bongo drums before his departure to Asia, there is a stack of drawings to his left, among them perhaps some he passed on to Meatyard.

Merton had started with direct brushwork on paper and, with characteristic curiosity and verve, moved on to a home-made, primitive, but effective form of printmaking. He would lay down a pattern in ink or make and then ink a pattern composed with found materials—envelopes from his voluminous correspondence, whatever else was at hand. And then press a sheet of paper, by hand, to take a single impression. The method was naïve, but the results could be impressive, not only to us but to Merton himself because he would never quite know what marks and textures would transfer. Chance or providence intervened; the finished work had its own trajectory, its own mind. Merton as artist was cooperating with … something. Something good, something that deeply interested and touched him. The process detoured the ego-driven notion that he was the artist, the skilled maker; the finished work emerged of itself.

The method was naïve, but Merton was not. He was aware of the interest in "aleatory" or chance art processes in the art of his time. John Cage, Jean Arp, and some of the Surrealists had pioneered the exploration of chance. He was aware as well of contemporary American art—Abstract Expressionism and Minimalism—through his friendship and correspondence with Ad Reinhardt, and he owned a small Black Painting, a gift from Reinhardt. Similarly, through his friendship and correspondence with the Zen teacher and author, D. T. Suzuki, Merton was aware of the tradition of Zen calligraphy and had received as a gift from Suzuki a truly classic calligraphic scroll which found its way to a hermitage wall. Few artists, perhaps none, could look daily at a Reinhardt Black Painting and a beautifully realized Zen calligraphy. This was Merton's working environment.

In the striking series of prints in the pages that follow, Calligraphy 1 is a perfect example of his way with found objects, in this instance envelopes creating a pattern that might be called sacred Cubism. The image relies on two contrasts, the first between a framing zone of darkness and a central zone of light, the second between strict framing geometry and the soft, shapeless, but vital form at the center. This is Merton's visual art at its best. It speaks—but what are we being told? Merton wasn't given to precise interpretation. He valued pre-verbal, visceral appreciation: another detour, this time around the chatty mind that thinks it knows. But isn't this a visual parable, a primitive but insistent vitality ascending at the center of a darkened, restrictive field? And grasped in this way, doesn't the image reflect religious experience? There is something scarcely known but insistent in our natures. Some would call it a will to live; others would experience it as a need to arise and find our way.

Calligraphy 3 conveys a different message. One of the results of Merton's printmaking process was what we might think of as dematerialization. The transferred image picked up some but not all of the ink on the source sheet. The result, as in Calligraphy 3, can be magical. One receives the impression of a creature, let's say a turtle on the move—but it's a spirit turtle, somewhat dematerialized, as much an abstract collection of spots as a proper portrait of a turtle. This impression can delight us, just as it surely surprised and delighted Merton, who never knew what the Good Lord would show him and show us when he peeled away the transfer sheet and had his first look.

Merton didn't mind the splotches, the unintended marks. They help to create a pictorial environment in which the event of meaning is possible. And meaning recreates the world. •

calligraphies

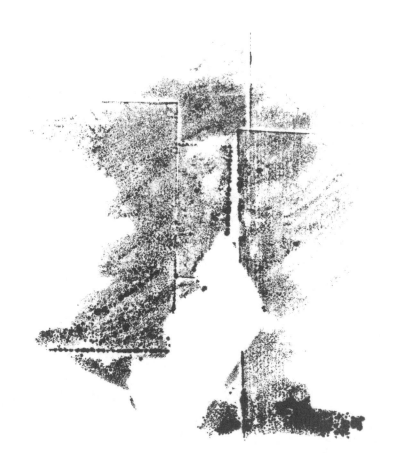

Could I have 5 or 6 more of your calligraphic drawings to mount and use on my store's walls?

SEPTEMBERR 10, 1968 LETTER FROM MEATYARD TO MERTON

Here are some artifacts. Pick the ones you want – and as for the others – what do you think? If you can get any buyers at $15 I will split the takings, and I can use the fortune in my Mars bar fund.

LETTER FROM MERTON TO MEATYARD

calligraphy 1

calligraphy 2

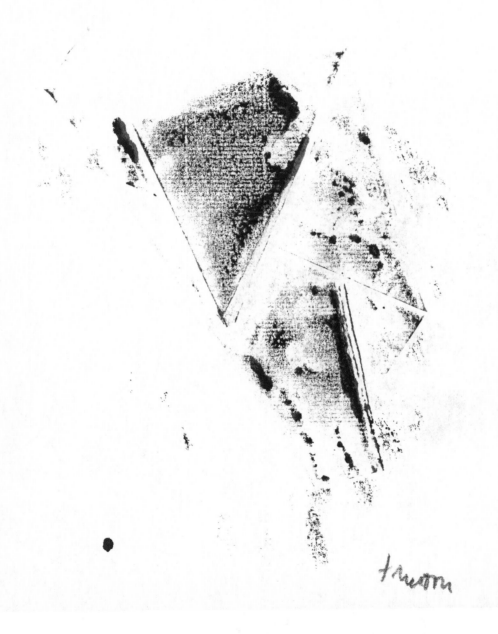

thom

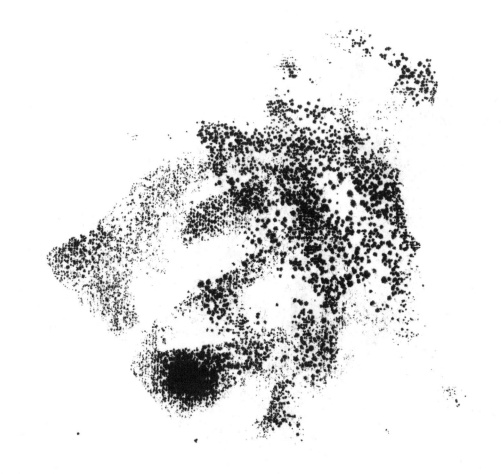

Do you yet remember my asking if it would be possible to put on a show here of some of your pictures and manuscripts–? Would like this for August - September.

JUNE 17, 1968 LETTER FROM MEATYARD TO MERTON

I've been one very busy and overvisited monk lately and I must admit I totally forgot about the exhibit of mss and drawings. You have drawings I think (I don't have much around now). I am sending herewith some mss and other bits and pieces. Among these items are a large number of copies of the Macaronic Antipoem. We might sell them 5 cents a piece for some worthy cause (would it be too much trouble to keep track?) like the Catholic Peace Fellowship.

JUNE 23, 1968 LETTER FROM MERTON TO MEATYARD

calligraphy 3

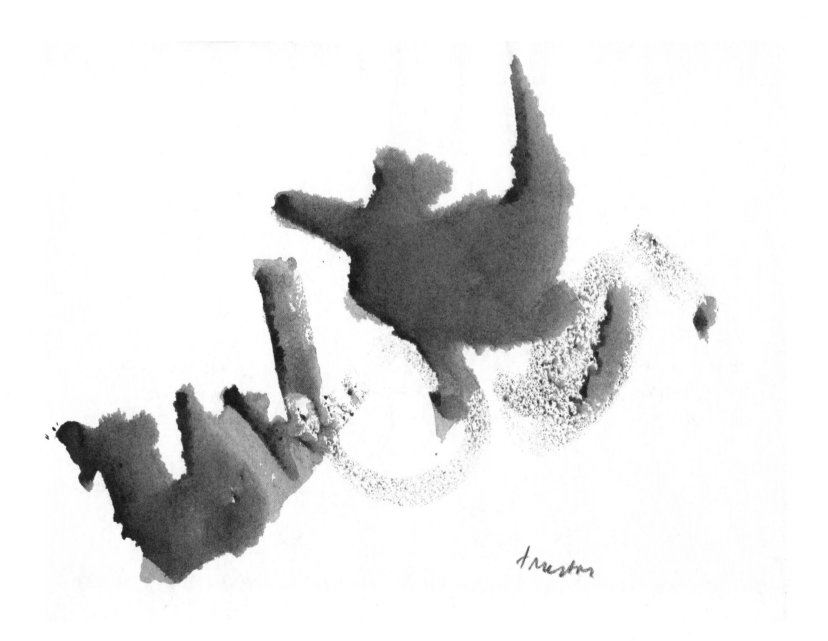

preston

calligraphy 4

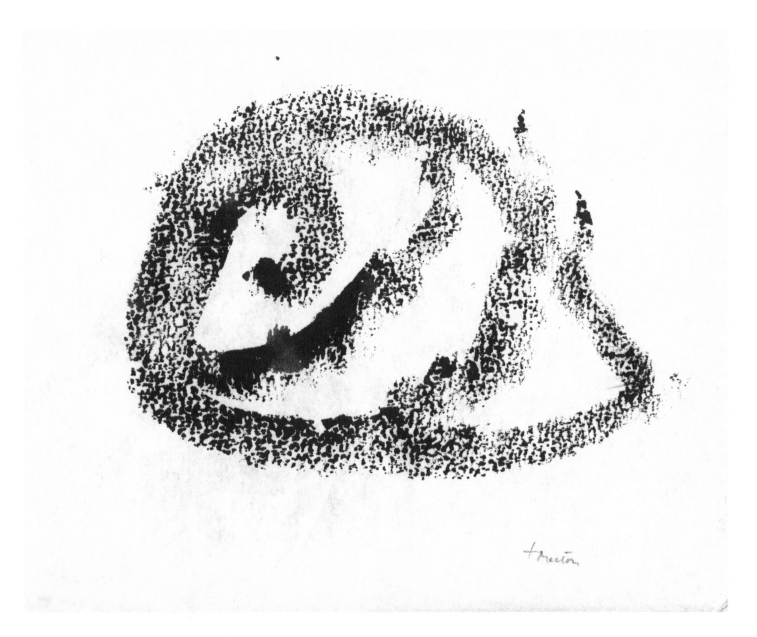

calligraphy 5

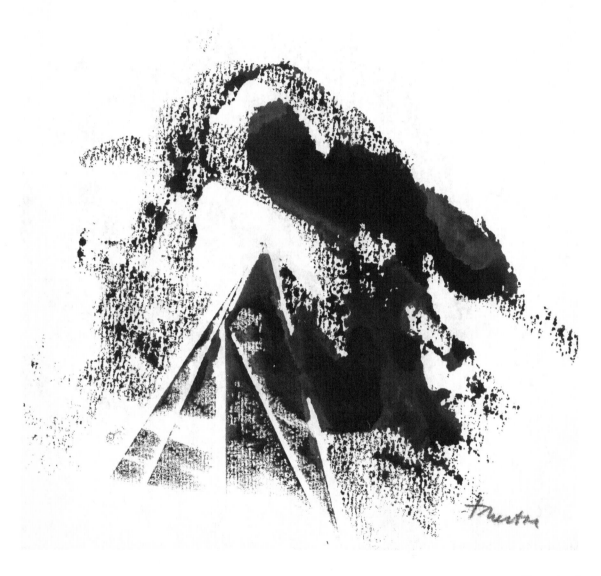

calligraphy 6

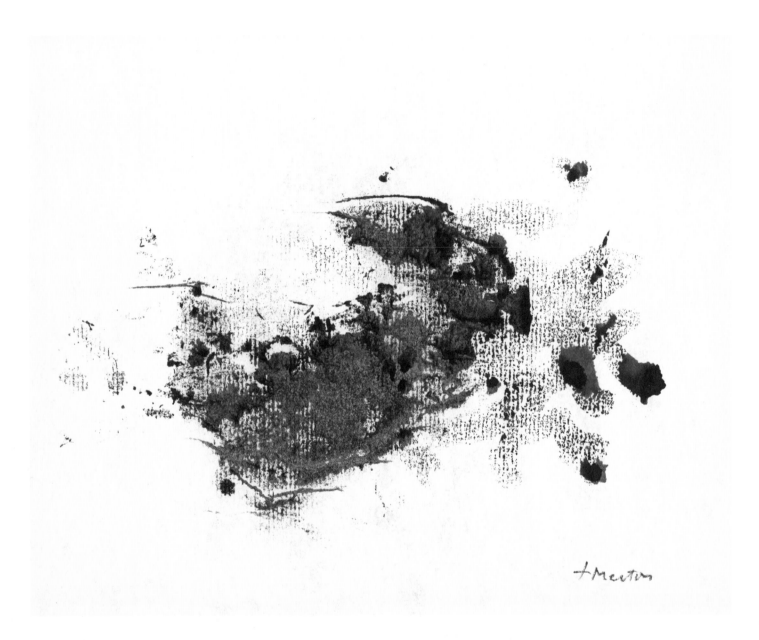

calligraphy 7

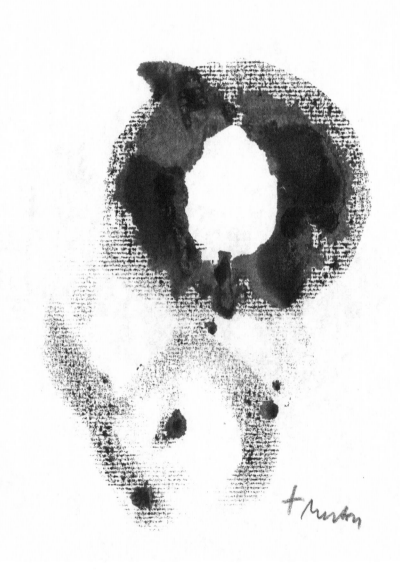

calligraphy 8

Merton and My Father:

If Thomas Merton and the photographer Ralph Eugene Meatyard were alive today and someone came up to them and asked if each would write something about the other, Gene and Tom would look at each other, grin, and roll with laughter. They were happy men. All the serious, momentous problems of the world could wait until the laughter subsided. In their own time they did comment on each other – "write" is too restrictive a word, for one wrote and the other photographed. No one needed to ask them to do it. It was their own business, their avocation, and they both had the good sense not to question themselves about it.

Common interests made Merton and Meatyard fast friends. Both were keenly interested in early Negro jazz, contemporary poetry, and Zen. They shared strong drink and impassioned conversation. Merton was especially attracted by a newfound possibility for profound visual expression communicated by the simple, direct medium of photography. Meatyard, on the other hand, was attracted to Merton by the monk's uncommon, Christlike openness to the unpredictable manifestation of God's will. Each man had worked hard for many years and had advanced a long way to be able to appreciate the diverse events which shaped one another's lives. Merton and Meatyard were brothers, not from birth, but from their reciprocal awareness and recognition of a rebirth from common aesthetic and spiritual grounds. So interrelated were their interests that the qualities of one man's work help to explain and interpret the other's. Both sensed that preconceptions of the varied evidences and artifacts of existence work to blind the individual from a real and meaningful experience of universal humanity. Moreover, each felt that access to this experience was open to each person through contemplation. And both, too, would be concerned that we should need to have their work explained, that we should find it anything more or less than self-evident. Our curiosity about them is heightened when we consider that Merton and Meatyard knew each other less than two years, at the end of their lives.

This article was begun in response to a question about the relationship of Ralph Eugene Meatyard to Thomas Merton. It expands somewhat beyond the narrow scope of that question to explore the commitment of Thomas Merton to photography and visual communication. Merton had much to say about both, but his statements and observations are scattered throughout his writings. This essay attempts to explore and relate a few of his insights as well as to interpret them, and to construct from them a kind of mosaic that forms a meditation about contemplative photography, an immeasurable dimension of photography that inspired both Merton and Meatyard. Many pieces are missing, but we can begin to recover what was submerged in Merton's thoughts from the ideas that he projected in his poetry and prose.

Photographs tangibly link the present to very precise moments of the past. Conventional photography has become a vital part of our heritage, serving as a matrix for visual as well as conceptual memory. Contemplative photography, on the other hand, provides a mental, visual awareness which helps to express the process of an individual giving up his own identity in favor of a greater collective identity. The act of the contemplative can be reasserted and rediscovered in the contemporary technology of photography in a way that goes beyond the influence of traditional iconography and in a way that goes beyond much of the production of conventional painters and sculptors. Contemplative photography extends the traditional role of the artist and permits a kind of visual reformation with a broader, less elitist, medium for spiritual expression-for Merton, we sense, an expression of the will of God.

It is important to note that Merton himself never developed a program as explicit as is stated here. In fact, he characteristically declared that he had no "program." I hope to make clear, however, that Merton's

involvement with the medium of photography shares something with the practice of Zen, a concept which itself develops no intricate dogmas. The topics of meditative photography and visual reformation in a Christian sense are complicated by Merton's increasing curiosity about Zen. Zen, a school of Buddhism which originated in India and spread later to China and Japan, posits the intuitive awakening of transcendental awareness and wisdom through individual contemplation. In Japanese, the word "Zen" actually means meditation. Adoctrinal, Zen relies upon the individual himself to attain enlightenment. Thomas Merton conducted a correspondence with D. T. Suzuki, one of the century's foremost Zen scholars, author of three volumes of Essays in *Zen Buddhism* (1927-34) as well as *The Training of a Zen Monk* (1934) and *A Manual of Zen Buddhism* (1935). Fascinated by oriental thought, Merton himself authored works with titles like *The Way of Chuang-Tzu* (1965), *Mystics and Zen Masters* (1967), and *Zen and the Birds of Appetite* (1968).

While Merton states that he thinks the Catholic Church and Zen are compatible, even interrelated in a spiritual sense, many of his readers will, perhaps, be aroused by an appearing heterodoxy. Merton nevertheless believed that Zen can only strengthen the Christian's understanding of, and relationship to, a world that is often openly hostile to the traditional forms of Christian expression. To illuminate Merton's own changing regard for traditional forms of Christian expression we may parallel how his earlier naïve view of photography evolved from a repulsion into an attraction, one important to his daily spiritual well-being.

Meatyard is historically pertinent to Merton's activity as a photographer, for Merton admired Meatyard's work. Meatyard, who supported his family as an optician, made Merton a pair of eye-glasses for his Asian journey so that the traveling "witness" could have a conventional 20/20 acuity (The glasses caught up with Merton via the post office.) The last time I saw my father and Merton together, a few days before Merton left for Asia, they discussed what Merton called "Zen camera," that other level of acuity which is a non-standard, non-institutionalized, inwardly free awareness. Merton, conscious of the proliferation of Japanese camera technology, perhaps savored the irony of a Christian monk viewing the world through the aperture of an eastern eye. Merton considered Meatyard's photographs the most "visionary" examples of photography that he had ever seen, and in the time that the two were friends, the example of Meatyard's photographs revived and strengthened in Merton a radically new awareness of photography.

Merton also referred to Meatyard's photographs as "mythical."[1] In his Asian journal he wrote that the "best photography" should be aware of, and make full use of, the most challenging type of "illusions." In most of Merton's writing, the terms "illusion" and "myth" are reserved almost exclusively for derogation. But in the context of the anti-logic of Zen these terms evoke a way to blast the foundation of preconception. Myth is used to smoke out and confront myth, and illusion draws out and confronts illusion.

Many of Meatyard's photographs of people recorded a figure wither masked or blurred from motion during the exposure. His use of masks at once objectifies an entwining convention of portraiture: a sitter's choice of pose and an artist's individual style. The mask here suggests a cultural urge to scrutinize transcendental moments of time; the mask and the pose resist time's fluidity. In contrast to his use of the mask, Meatyard photographed people in motion, recording the continuous flow of their action to convey the living flux of their identity. Conventional photography is a medium through which the photographer projects his will to possess and define objects. Contemplative photography, by contrast, is a nonprescriptive approach to discovering the balance between the objective and the subjective. In reviewing a photograph contemplatively inspired, we may rediscover the consummate relation between the subject and the object.

The potential scope and meditative practice of contemplative photography may be elaborated by reference to various passages in Merton's writings. His photographs are another matter. Merton's own images-the numerous ones that we seldom see, the ones with garbage cans, construction sites, airplanes, restroom signs, telephone wires, and dilapidated houses deliberately juxtaposed against the "view"- share common elements with those of the photographer Robert Adams who, in the book *The New West*, observes: "Many have asked, pointing incredulously toward a sweep of tract homes and billboards, why picture that?" Answering himself, Adams continues. "One reason is, of course, that we do not live in parks, that we need to improve things at home, and that to do it we have to see the facts without blinking."[2] The assembled physical surfaces captured in photographs comprise the vehicle for the spiritually informed contemplative image, cosmetic or not. As individual artifacts they necessarily remain outside of the contemplative experience. Interpretively, these surfaces can still communicate through theology or Zen. The full measure of contemplative photography can only be experienced intuitively.

Except in his poetry and in some freewheeling letters, Merton always tries to be as coherent as possible in order to communicate the evasive thoughts and emotions of his particular spiritual insight. Meatyard's photographs, then, have the most in common with Merton's poetry, especially the later poetry, such as Cables to the Ace. Both Merton and Meatyard use the anti-logic of Zen to ambush and slough off the lazier reader and viewer. The deliberate ambiguity in Merton's later poems and in Meatyard's photographs is a teaching tool, and we will be obliged to consult the methods of Zen to appreciate them.

Merton and Meatyard differed in religious commitment-one was a Catholic monk, the other a Protestant layman. Nevertheless, they shared a common perspective. Both believed that God is Being itself, the pure act of existence; that everyone and everything is an extended part of God; that each is a "created attachment."[3] Similarly, but long before he met Merton, Meatyard titled a sequence of nine abstract photographs with a quotation from Meister Eckhart:

> God expects
> but one thing of you
> and that is
> that you should
> come out of yourself
> insofar as you
> are a created being
> and let God be God
> in you![4]

That which we perceive as matter is the merest skin of God, a being about whose substance we are no more knowledgeable that of the void of nothingness. We share this skin for a brief while. Our eyes witness a vast horizon, but only in contemplative moments do we experience the totality to which we contribute.

In further developing the theme of contemplative photography we must explore Merton's regard for the visual image, especially the image of "man," and its relation to the image of God. In *The Seven Story Mountain* Merton criticizes the tendency of western culture to believe that the main goal in the individual's life is to attract the attention and favorable opinion-even applause-of peers: "A weird life … to be living always in somebody else's imagination, as if that were the only place in which one could at last become real!"[5] Merton, in this passage, is just insofar as our egocentricity lends itself to these extraordinary discrepancies of perception, but his thinking goes beyond the relation of men to each other. In *New Seeds of Contemplation*, Merton addresses the tension between the individual and the universe, and his words suggest a pictorial expression: "It is possible to speak of the exterior self as a mask: to do so is not necessarily to reprove it. The mask that each man wears

may well be a disguise not only for that man's inner self but for God, wandering as a pilgrim and exile in His own creation."[6] We are God's masks-we can acknowledge the indweller; live in total preoccupation with the surface; or we can acknowledge the relation between the indweller and the "vesture" of the surface. "It is as if in creating us God asked a question, and in awakening us to contemplation He answered the question, so that the contemplative is at the same time, question and answer."[7] This engaged intuition is approached and attained through the disciplined, frustrating, practice of confronting our disunion with God. Contemplative photography embraces the contrast between our union and disunion with God. Our "wisdom in love" intensifies in contrast to our "suffering" of egocentricity.

Merton was a master of the art of verbal portraiture. He speaks to us in an era of technological revolution and world war, and an era in which the tradition of Christianity is submerged in secularity. Merton's own extensive self-portrayal depicts an exemplary quest for spiritual renewal. Concentric to his verbal expression Merton, a painters son, evidenced a lifelong interest in expressing himself in a visual medium. He made thousands of calligraphic drawings which he described as seeds that "came to life" as "summonses to awareness" which may open the way to unconscious harmonies and "new, intimate histories."[8]

Merton also made a lifelong exploration of photography, and he initially despised it almost as much as he later revered it. For Merton, commercial photography was symptomatic of mass conformation to suppressive ideologies. On the other hand, toward the end of his life, Merton sensed in photography the potential to communicate with a society generally more conversant with its technological appendages than with its inner self. Photography, he felt, could inspire a reassessment, a dialogue, between the inner self and the skin of mechanism which technologists busily perfect as man's new, but eternal image-a dialogue which can evolve into a more fulfilling emergence of human potential.

The problems of photography stayed with Merton for many years. At the time of his death he was just beginning to formulate the terms of a solution. The photographic image he regarded as a mental tool, like language. The "best photography" conveys "thought"-"not so much what you saw as what you thought you saw."[9] While Merton was familiar with a wide range of the work of various photographers, it was the Meatyard photographs, coupled with the two men's mutual interest in Zen, that prompted an eventual reassessment of the vital potential of photography. But Meatyard's final influence played no part in the long formative period of Merton's exploration of photography, for Meatyard was just born when Merton was ten years old and receiving his first camera.

As an artist's son, Merton makes this observation: "The integrity of an artist lifts [him] above the level of the world without delivering him from it."[10] Merton felt that he inherited his father's way, the artist's way, of looking at things. Owen Merton's "vision of the world was … full of balance … veneration for structure, for the relations of masses and for all the circumstances that impress an individual identity on each created thing."[11] Impressed by the example of his father, he believed that the artist's way of looking at things could, in some measurable way, reform the problematic world. The artist redeems the "individual identity", of created things by a qualitative isolation and observation. Although overwhelmed for many years by the momentary attachments and attractions of the everyday world, Merton participated in the redemptive act of detachment which informs contemplative photography.

Merton lived for several years at Douglaston with his maternal grandparents. His grandfather worked in a publishing house which specialized in photographic picture books, and Tom spent some Christmas money on three photographically illustrated volumes. His experiences with them parallel his later obsession with Mount Kanchenjunga:

I want to be in all these places, which the pictures of Le Pays de France showed me: indeed, it was a kind of a problem to me and an

unconscious source of obscure and half-realized woe, that I could not be in all of them at once.[12]

At age eighteen Merton went to Rome trying to reconstruct from the ruins an image in his mind of the ancient city. Besieged by post-card sellers and lost in the ancient and modern maze of fragments, he began to realize that the untouched ruins were probably more beautiful than the original city, which he came to imagine as a monstrosity of institutions and slums. The presence of the city surpassed his anticipation of it through words and pictures. When Merton saw the dome of St. Peters, for example, "the realization that it was not a photograph filled me with great awe."[13] Merton's wanderlust in Rome led him by churches; he bought a Vulgate Bible so that he could learn to explore the pictorial meaning of these images more fully. Even after twenty years in a monastery, the influence of Le Pays de France lingered, and the temptation to view, to explore, to "be in all those places" continued to trouble Merton, and his own impulse he recognized as a fully human and perhaps partially worldly one.

Photography is one of the principal mechanisms of propaganda for our image-conscious collective identity, a "society that is imaged in the mass media and in advertising, in the movies, in TV, in best-sellers, in current fads, in all the pompous and trifling masks with which it hides callousness, sensuality, hypocrisy, cruelty, and fear."[14] Merton calls the mutable, superficial appearance of our modern "self" a "mask." We are conditioned and quantified by social and economic forces to shape and conform our appearances and behavior to a common archetype, one often formulated as a myriad of products available for a price. We suppress the awareness of our own "contingency," our "state of radical need,"[15] by creating an image of ourselves as one that has no need that cannot be filled." "Because we live in a womb of collective illusion, our freedom remains abortive. Our capacities for joy, peace, and truth are never liberated."[16] In the process of trying to become part of an all-powerful, all-seeing, all-knowing, infinitely-quantifying, formulating,

and controlling institution, the individual "becomes part of a mass-mass man-whose only function is to enter anonymously into the process of production and consumption."[17]

Merton argues that our flesh is inevitably "vulnerable to death and demise." Our excessive and futile preoccupation with the perfection of our mask robs us of the more fulfilling and enriching experience of our true inner-selves-the Unmasked, the Unspeakable. "Now if we take our vulnerable shell to be our true identity, if we think our mask is our true face, we will protect it with fabrication even at the cost of violating our own truth."[18] Ultimately Merton resolved the problem of our self-image into layers of spiritual penetration. The mask of our image-conscious culture is an "unprepossessing surface" through which we may patiently "break through to the deep goodness that is underneath."[19] As Merton evolves with this concept, the next layer is the mask of Christ; through that, the mask of God; beyond God the Void of the Absolute.

Merton felt that if the medium of photography could lead a culture into a material complication of its own suffering, then perhaps this same medium could illustrate or communicate the freedom to be gained from a voluntary path of monastic asceticism. Merton came to identify the suffering of attachments and detachment inherent within the medium of photography with the transfiguring love and suffering of Christ. This same medium through which one's egocentricity expands and proliferates is turned into an act of meditative surgery revealing and removing the deceits of attachments. For Merton the photograph is the ground where one's suffering becomes "wisdom in love."[20]

Certain aspects of the structure of the photographic process appear mechanically parallel to elements of monastic life. The monk's cell is similar to the empty dark chamber of the camera. The monk's inner focus and exposure to a transfiguring light, his latent retainment and gradual development of a mystical experience, is coincidental to the process of exposure and development of a photographic negative or

print. The early literature of monastic mysticism developed a vocabulary of Neoplatonic negativism to express an inner vision of the "uncreated light" and a "darkness clearer than light" expounded by such writers as Dionysius the Areopagite (6th century), Gregorious Palamas (c. 1296-1359), and Meister Eckhart (c. 1260-c. 1327). Aware of this tradition and the coincidence of terms, one of the most pertinent and informative structural components of the photographic process for Merton, is the way in which light is converted into a black emulsion on transparent film so that a new exposure is needed to transfer and fulfill the image's intended form.

Merton clearly alludes to this dialectic structure of photography to resolve a transference of identity in two related passages where he describes his conception of a union with Christ: "enter into the darkness of interior renunciation, strip your soul of images and let Christ form Himself in you by His Cross"; "There Christ develops your life into Himself like a photograph."[21] Despite admonishing images Merton's Christ manifests his presence most veritably in the form of an image. While on the one hand Christ is an image born inside of the individual, the individual is also an image born inside of Christ. In terms of photography the world is like a negative image, latent or developed, awaiting the transfiguring illumination of Christ. The accounts of Christ's own life exemplify a radiant focus that by-passes any tradition or institution which attempts to mask or mitigate the will of God. Still photography incises reality as a decision or judgment. For Merton contemplative photography is an awareness of our particular imminent judgment. With photography, we confront this limit of knowledge, the Unmasked, the Unspeakable, in seeing the desirable photograph through the camera yet choosing not to take it. The medium of the photograph is essentially a mechanism of choice.

The biographer John Howard Griffin said Merton had no interest at all in "ordinary" photography and that he seemed to use it as an instrument or focus for "contemplation."[22] The act of contemplation itself, as Merton defined it, is an existential abandonment of all prior terms or ideologies. The conceptual ideal of contemplative photography is a focused goal for meditation and it only survives the act of contemplation as an imagistic metaphor. The medium of photography can expose the suffering of one's identity, and we can apply contemplative insight toward attentive personal revisions of the visible world. In further communicating contemplative / meditative awareness Merton turned to Zen, which he felt shared something in common with all mediums of spiritual insight. Zen, accompanying traditional forms of Christian expression, has more potential to foster a contemplative enlightenment as well as to take back to the world a meditative method for actualizing the redemption which Christianity has to offer. Merton called the camera that he used a "Zen camera."[23] Comparing Zen with Catholicism Merton wrote, "one offers man a metaphysical enlightenment, the other a theological salvation … [U]nder the unifying power of the Zen discipline and intuition, art, life, and spiritual experience are all brought together and inseparably fused."[24] For Merton the "Zen camera" becomes "inseparably fused" with Catholicism. Contemplative photography becomes a vehicle of "metaphysical enlightenment" with the potential to prepare us for "theological salvation."

Zen is neither theology nor aesthetic tenet. One finds Zen already there, in religion or in artistic expression. Zen is the Absolute and the Non-Absolute. It exists in the world of opposites but is not itself distinct. Merton confronts the problem directly in Zen and the Birds of Appetite, where he elaborates the "embodiment of the Absolute mediated through the personality of the artist. The contribution of Zen to art is then a profound spiritual dimension and transforms art into an essentially contemplative experience in which it awakens the 'primal' consciousness hidden within us and which makes possible any spiritual activity."[25]

In his Asian journal Merton wrote of his obsession to photograph Mount Kanchenjunga. He conveys his experience with a kind of naiveté that desires to walk you through the experience. The camera, he says, cannot capture the mountain in a post-card view:

> It captures materials with which you reconstruct, not so much what you saw as what you thought you saw. Hence the best photography is aware, mindful, of illusion and uses illusion, permitting and encouraging it-especially unconscious and powerful illusions that are not normally admitted on the scence.[26]

Mount Kanchenjunga is the third highest mountain in the world. It was first scaled by a British team in 1955, which is probably when it entered Merton's imagination, gradually becoming an emotional symbol fusing adventure, physical hardship, perseverance, extreme solitude, and grandeur. While Merton only mentions taking three photographs of the mountain, his negatives reveal that he possibly took two or three dozen of that subject from a wide variety of angles and in widely differing compositions. However, the mountain was far away and Merton was probably frustrated by his inability to convey a feeling of its massive proportions. Merton was nursing a bad cold. He found himself constrained to contend with a mountain that was so far away that it was dwarfed in scale by the trees and buildings in his immediate environment. He was compelled to release his obsession with the mountain and turn his interest to what was more readily accessible in the immediate environment-the shapes of tress, buildings, people.

Merton had lived in many places during his youth, and stimuli such as the photographs which he saw in Le Pays de France inflamed him with an insatiable wanderlust. And at first he wanted to possess what he saw, as one in a sense can in photographs. Modern communication, to be sure, uses photography to seduce us, in the case of advertising, into acquiring a pictured object, and, in the case of news and literary media, to acquire a story behind the photograph. It uses unconscious and powerful illusions to attract us to the image. It was in response to this that Meatyard used Zen techniques of anti-logical illusion to expose the mechanism of obsessive attraction and to detach, if not repel, the viewer; he fosters contemplative detachment in witnessing the object. We do not have to desire to possess everything we see, nor do we have to desire to re-enact or explain every event. We can experience the past and the present in a mindful and contemplative mode and be free to go forward into an infinite world of new and unrealized possibilities.

Merton and Meatyard seek to cultivate a kind of detached awareness. Merton observes how the oriental style of Zen art deals with detached awareness through abstraction and minimalism. Oriental calligraphy, he writes, "reveals to us something of the freedom which is not transcendent in some abstract and intellectual sense, but which employs a minimum of form without being attached to it, and is therefore free from it."[27] The "Zen camera," with its focus of universal awareness, is a means of experiencing our immediate detachment from visible objects. While the essence of photography is its minimal and abstract grasp of reality, it is more commonly assumed to be a medium of pure factualization. Yet, as Zen makes us aware, once a fact is isolated from the stream of reality, it becomes a misrepresentation, an illusion, a contradiction.

Merton saw in Meatyard's photographs a contemporary and pervasive vehicle for communicating the Zen experience. Meatyard's photography contains what Merton termed "the classic Zen material":

> Curious anecdotes, strange happenings, cryptic declaration, explosions of illogical humor, not to mention contradictions, inconsistencies, eccentric and even absurd behavior, and all for what? ... [T]he paradox and violence of Zen teaching and practice is aimed at blasting the foundation of ready explanation and comforting symbol out from under the discipline's supposed "experience"...

The purpose of this seismic confrontation is "to destroy the specious 'reality' in our minds so that we can see directly."[28] When we plunge into photography with this awareness we can begin to contemplate the full, stark contrast of our detachment from reality against the implicit confidence in facts with which we are born. We can begin to feel the emptiness of the Void that separates surfaces-the sense of the eye, the tympanum of the ear, the touch of the finger. The Zen camera makes Merton a seeing artist and gives him an aesthetic kinship with his artist father, Owen Merton, and with the visionary William Blake, the subject of his graduate thesis at Columbia University, and with his friend and fellow photographer, Ralph Eugene Meatyard.

In Seeds of Contemplation Merton cautions that contemplation cannot be taught, just as the Zen masters deny that they are teachers. The awareness is given as a gift, which we can all freely receive if we are receptive. In the Zen tea ceremony the water fills the pot, divides and empties from the pot to fill cups, divides from cups and pours in gifts of life to fill ourselves. The contemplative photograph is given to the "Zen camera," and then is a gift to the eye. •

[1] Michael Mott, *The Seven Mountains of Thomas Merton* (Boston: Houghton Mifflin, 1984), 476.

[2] Robert Adams, *The New West* (Boulder: Colorado Associated University Press, 1974), 11.

[3] Thomas Merton, *Seeds of Contemplation* (New York: Dell, 1960), 173.

[4] Nancy Wilson Ross, ed., *The World of Zen: An East-West Anthology* (New York: Random House, 1960), 242.

[5] Thomas Merton, *The Seven Storey Mountain* (New York: Signet, 1963), 323.

[6] Thomas Merton, *New Seeds of Contemplation* (New York: New Directions, 1961), 296.

[7] Thomas Merton, *New Seeds of Contemplation*, 3.

[8] Thomas Merton, *Raids on the Unspeakable* (New York: New Directions, 1966), 181-82.

[9] Thomas Merton, Patrick Hart, James Laughlin and Naomi Burton Stone, *The Asian Journal of Thomas Merton* (New York: New Directions, 1975), 157.

[10] Thomas Merton, *The Seven Storey Mountain*, 9.

[11] Ibid.

[12] Thomas Merton, *The Seven Storey Mountain*, 48.

[13] Thomas Merton, *The Seven Storey Mountain*, 109.

[14] Thomas Merton, *Conjectures of a Guilty Bystander* (Garden City, New York: Doubleday, 1966), 36.

[15] Thomas Merton, *Raids on the Unspeakable*, 15-16.

[16] Thomas Merton, *Raids on the Unspeakable*, 16-17.

[17] Thomas Merton, *Conjectures of a Guilty Bystander*, 64.

[18] Thomas Merton, *Raids on the Unspeakable*, 15.

[19] Thomas Merton, *Conjectures of a Guilty Bystander,* 234.

[20] Thomas Merton, *Zen and the Birds of Appetite* (New York: New Directions, 1968), 51.

[21] Thomas Merton, *New Seeds of Contemplation*, 157, 162.

[22] John Howard Griffin, *Follow the Ecstasy: Thomas Merton the Hermitage Years, 1965-1968* (Fort Worth: JHG/Latitude Press, 1983), 10.

[23] Michael Mott, *The Seven Mountains of Thomas Merton*, 516.

[24] Thomas Merton, *Zen and the Birds of Appetite*, 2, 90.

[25] Thomas Merton, *Zen and the Birds of Appetite*, 90.

[26] Thomas Merton, Patrick Hart, James Laughlin and Naomi Burton Stone, *The Asian Journal of Thomas Merton* (New York: New Directions, 1975), 157.

[27] Thomas Merton, *Zen and the Birds of Appetite*, 6.

[28] Thomas Merton, *Zen and the Birds of Appetite*, 34-35, 46, 49.